Max Early's poems—each a praise song—weave us back into the beautiful, eternal dance of earth, water, sky and creature life. We watch the seasons pass at K'awaika and the poet-potter's words remind us: make and sing, "pass the blessing door to door." And along with Grandmother ("Grandma Linda's Polishing Stone") I say to the poet: "Mameh on-u-meh gusa-sue."

—Valerie Martínez, *And They Called It Horizon*
Santa Fe Poet Laureate (2008-2010)

Poetry and pottery are art forms simultaneously ancient and yet made for the moment. The words flow like coils of clay to surround the reader and build a vision of the mind and soul of the poet. Potter Max Early's poetry in *Ears of Corn: Listen* reveals much about life in his native Laguna Pueblo. More importantly, it gives a modern voice to an ancient culture, making it relevant for both a new generation and also those outside the Pueblo. The poems tell his story of how, "Breaking gender taboos didn't turn me to stone," and the delicate balance he finds between embracing modernity and reveling in the past. The use of native Laguna words adds grace to the poems, much like a perfectly painted vessel; they lyrically draw the eye, create balance and provide a connection to the viewer. Not only is Max's collection of poems worth a read, but a second read as well. The first time they may just seem pretty, but the second time the novelty is gone, and the substance remains. Much like Max's pottery.

—Charles S. King, *Born of Fire: The Pottery of Margaret Tafoya* and
The Life and Art of Tony Da

Accomplished potter Max Early turns his hand to a new medium in this debut collection. Stories of family and tribal life are featured in a wide variety of forms, from pantoums, to free verse, to lyric prose. The witch stories and other traditional tales are particularly compelling, but the entire collection creates a vivid picture of Laguna life, all told with a storyteller's flair.

—Lisa D. Chavez, *In An Angry Season*

EARS OF CORN:
LISTEN

EARS OF CORN: LISTEN

POEMS

Max Early

THREE: A TAOS PRESS

First U.S. edition 2014

Book Design & Typesetting: Lesley Cox, FEEL Design Associates, Taos, NM
Press Logo Design: William Watson, Castro Watson, New York, NY
Front Cover Art: Marla Allison, *Summer Ends Too Soon*
Section Art: Norvin Johnson
Author Photograph: Marla Allison

Text Typeset in Avenir

Photograph on page 5 printed by permission of the National Museum of the American Indian, Smithsonian Institution (Catalog Number 26923). Photo by NMAI Photo Services.

Photograph on page 15 printed by permission of the National Anthropological Archives, Smithsonian Institution (Inventory Number 06871900).

Printed in the United States of America by Cottrell Printing Company

ISBN: 978-0-9847925-5-9

THREE: A TAOS PRESS
P.O. Box 370627
Denver, CO 80237
www.3taospress.com

10 9 8 7 6 5 4 3 2 1

For my children:
David, Alan, and Maria

For Fanithya

For Norvin

For Grandma Linda-sheh

For Mom and Dad

Contents

III FALL

IV WINTER

V Clay Variations

PREFACE

When Grandma Linda's truck broke down going up the hill called *cuesta* towards Paguate, New Mexico, my mother, Peggy Rose, and her sister, Ruth, were stranded by the roadside. My father, Harry, and his friend, Kenneth, soon drove by and pulled over to help the girls. This is how my parents met and later married in 1951.

I am the youngest of four boys—Harry, James, David, and I. My mother is from Seama, New Mexico. Her matrilineal clan is Turkey. So I am *Tsi-na Hanew*, from the Turkey People. A native of America, the wild turkey flourished alongside the Indigenous tribes for millennia. Concurring with the idea of Benjamin Franklin, I would have preferred the turkey as the national bird of the United States. Franklin wrote, "For in truth the turkey is in comparison a much more respectable bird, and withal a true original Native of America. He is besides, though, a little vain and silly, a bird of courage."[1] Furthermore, the wild turkey has provided sustenance across North America and still plays a significant role in many Native American cultures. The Turkey Clan of Laguna Pueblo represents this connection.

My father is from Paguate, New Mexico. His matrilineal clan is Bear. So I am a child of the clan or bear cub—*Kwa-ya wahchee*. Throughout my childhood, I identified myself with Smokey and the Travelodge's Sleepy Bear. Likewise, I am adored by my *sagooya*— my father's clan sisters. Our *sagooya* hold a sacred place among our people and help their little ones throughout life's journey.

The people of Laguna Pueblo associate kinship in their matrilineal clans. We have fourteen clans that assist in identifying ourselves within our pueblo and with other tribes: Turkey, Bear, Water, Sun, Turquoise, Oak, Antelope, Badger, Lizard, Corn, Eagle, Parrot, Coyote, and Roadrunner. Before any Europeans arrived, we didn't have English or Spanish surnames. To a certain extent, our clans correspond to Pueblo surnames. The clans have embodied our traditions through culture and language since prehistoric times.

Our oral history reveals that we have lived here in the Southwest region of the United States since time immemorial. We are descendants of the Ancestral Pueblo people, or Anasazi. Like the other Keresan Pueblos in New Mexico, Lagunas believe our ancestors originated from *Sipapu*, somewhere around the Mesa Verde area of Colorado. We are related to the ants and emerged into this world the same way. Pueblo people model themselves after the ants because they are communal and industrious. Our legends state that our ancestors migrated south to our present location around the 1200s. Our migration and journey are recounted in traditional songs.

The Pueblo of Laguna is located 45 miles west of Albuquerque. Interstate 40 passes through our tribal lands along with Route 66 and the Santa Fe Railroad as precursors. Laguna village is the capital where elected tribal delegates meet in council. Six major villages comprise the people of Laguna Pueblo: Seama—*Tsiyama*; Paraje—*Tsimuna*; Encinal—*Buniguyya*; Paguate— *Kwisch-chee*; Laguna—*K'awaika*; and Mesita—*Hatsatsi*. There are several hamlets also within the pueblo: Philadelphia, New York, Harrisburg, New Laguna, China Town, Casa Blanca, and El Rito.

Laguna Pueblo is a federally recognized Native American tribe. Laguna means *lagoon* or *lake* in Spanish. An extinct lake once resided near the village. The Keresan name of our tribe is *K'awaika*. The population of the tribe exceeds 8,200 enrolled members, making Laguna the largest Keres-speaking Pueblo.

There is no reference to our tribe in Spanish records until 1697. The Spaniards considered this entire area the Acoma province. As told in history books, the founding of Laguna happened in 1699. Supposedly, Laguna was established by other Keres-speaking people from the northern pueblos shortly after the reconquest of New Mexico in 1692. De Thoma writes, "The Queres of Cieneguilla, Santo Domingo, and Cochiti constructed in the same year (1699) a new pueblo close to an arroyo, 4 leagues north of Acoma. On the 4th day of July, in

1699, this pueblo swore its vassalage and obedience, and received the name of San José de la Laguna."[2] On the other hand, our elders tell us that we were already here before the 1699 founding. The northern group of Keres that did migrate here would have brought their clans with them and their separate Keres dialects. Our own vernacular of Keres is distinct from the other six Keresan Pueblos of Acoma, Cochiti, Santo Domingo, San Felipe, Santa Ana, and Zia. The Keres Pueblo of Cieneguilla is no longer in existence.

The reservation of Laguna Pueblo is approximately 530,000 acres and is surrounded by beautiful mesas of sandstone, lava, and shale with *Tsee-binna*, Mount Taylor, rising above. The hillsides are dotted with cedar, piñon, and various clay deposits that are used in the production of pottery. The nineteen Pueblos share a legacy of tribal imagination through individual and communal essence in the tradition of pottery making. Laguna pottery is part of the American Indian Southwestern tribal art. Local clay sources are utilized to create water *Ollas* that represent rain clouds.

The key factors in the process of Laguna Pueblo pottery making are intertwined with the philosophy of the Pueblo people with reverence to Mother Earth—*Niya Hotzee*. The relationship of harmony and balance in the knowledge of kindred spirits helps to bring forth the being representing the pottery vessel as a living entity. This is achieved by grinding ancestral pottery shards to mix with the clay, thereby establishing strength, durability, elasticity, continuance, and connection with the ancient ones.

The craft is traditionally considered a woman's craft, passed down usually from mother to daughter. In my case, Grandma Linda would let me paint her dry, polished pieces, but I couldn't work with the clay because, as she put it, "It's ladies work." I spent my high school years helping her paint all her pottery because arthritis had disabled the finer dexterity she once had. This didn't stop her from getting her hands dirty though, since she loved to make pottery. We were

a great collaboration. I soon developed the precision to create exquisite designs and started painting commercial ceramic greenware when I moved away to attend college.

I couldn't feel any life in the commercial pieces I painted and wished that I could work with the Clay Lady. I looked about the pueblo and saw the transition of labor tasks switch gender. Men were building outside bread ovens and plastered houses with adobe mud, and women went to village meetings and made moccasins. "So why not make pottery"? I asked myself. I was determined to make a large, twelve-inch water *Olla*, but I didn't have the skills. I had watched my grandmother roll her coils of clay out countless times, so my hands already knew what to do. I showed my grandmother my first creation, and she didn't object as I thought she would. She said, "*Mameh on-u-meh gusa-sue! Dawaaeh*": "You sure know how, it's very nice, thank you."

All pueblo pottery is hand-coiled and not thrown on a wheel. After building and sanding the pot, a white, chalky, clay slip called *epcha* is applied in several coats. A smooth, polished river stone is hand-held by the potter, and the entire surface of the vessel is burnished by the stone. The burnishing effect develops a glossy, sleek, mirror reflection of slipperiness that feels wonderful to the touch. The river stone's smoothness comes from the constant flow of current water. These stones are passed down to family members who are willing to continue and have the ability for making pottery. My own polishing stone once belonged to my dear *Ba ba-ah*, Grandma Linda.

The creamy-white, stone-polished surface serves as a background for the black hematite paint pigment and native clays' slips of red, orange, and yellow. These paints create the designs that encompass the body of the pot. Different motifs of clouds, rain, lightning, thunderbirds, butterflies, flowers, fowls, sun, and corn are some of the Pueblo potter's views of painting images associated with life-giving water. Prayer for rain on a canvas of clay helps bring life to the desert. Once in a while, when a drought persists, an *Olla* is broken to call the rains. The people say "*Peh-eh-cha*": "Let it rain."

Once the designs are finished, the potter paints a straight line around the bottom of the pot to separate the earth from the sky. The line circulates to a quarter-inch opening and intentionally doesn't complete the circle. Hence, the pot can breathe. Called the *spirit line*, it symbolizes the life force the potter puts into the vessel. The *Olla* is fired outdoors with wood and manure to capture the transformation from clay to stone. The cooled pottery is breathed upon by the potter, giving life to the vessel. Following this, now the pottery can hold water, with prayers for rain and bestowing thanks to the rain spirits, *Shi-wanna*. The pottery exists to quench our thirst and provide life as a rain cloud does.

Pottery became a part of my life when my grandmother introduced me to the Clay Lady. This was during my high school years while living with my grandparents. Those were special days, I often recall, like the time I arrived home from school one day. Opening the door, I smelled the freshness of rain coming from my grandmother's kitchen. She said, "*Saba ba-ah gu'maatsani guymet-eh*": "My grandson, help me please!" Then, "Can you wash the walls up there by the ceiling beams? I can't climb up this ladder anymore. It gets me dizzy." Turns out, before I knew it, I had whitewashed all my grandma's rooms of adobe walls with gypsum. Working side by side, she cleaned up my mess as we went along.

Such a humorist, Grandma Linda had a teen-ager's mentality. Whenever we planned trips too far in the future, like deer hunting, Grandma always said, "We'll go, as long as I'm still living." She'd laugh, and she thought it was funny, amusing herself with the different reactions she got from family members. On the contrary, Grandma Linda had the wisdom of a medicine man. Out of the blue, Grandma sometimes suggested we go for a hike behind the house to look for different kinds of native herbs. She would use them for healing or cooking. When my grandfather and I went after firewood, I would gather certain plants for my grandmother. Grandpa Philip would ask, "What's that for?" I'd tell him, "It's Grandma's back medicine,

guysh-cha wawa," or "It's Grandma's blood medicine, *mot-tsee wawa.*" Grandpa would chuckle and reply, "You and your grandma are like medicine men."

Every evening at the dinner table, a story unfolded. Grandma talked about how it used to be in the good old days before television, electricity, and indoor plumbing. Both of my grandparents grew up hearing the Laguna legends and animal tales about Coyote, Turkey, Hummingbird, Frog, and Badger, to name a few. I was told various stories of our emergence, migration, and the settling of Laguna. Grandpa liked to talk a lot about hunting, planting, and war. We would spend hours at the table listening to Grandpa Philip's World War II stories while Grandma Linda and I washed dishes.

Grandma and Grandpa always had a chore waiting for me when I got home from school, yet they mentored me on these tasks: roasting corn in the outside oven, mud plastering the barn, building with sandstone, chopping firewood, planting corn, and painting doors turquoise. Grandma would always say in her lighthearted way, "Don't be in a rush about what you're doing, so it can come out right." When the three of us went deer hunting, Grandma would say, "Don't be like Coyote; he's always in a hurry." They taught me to cherish the ordinary and see patiently within everything around me.

Acquiring patience definitely fostered my path as an established Pueblo potter. I'd spend countless hours persistently painting and polishing brilliance in my work. Subsequently, it felt like my hands were doing all the work while my mind drifted off with language, music, and thought. I found I had reached my pinnacle as a traditional potter, so I decided to return to academia to learn another medium. I thought about art school at first, but I didn't want to go through the struggling artist routine again. Also, my career for over the past ten years had been as a Field Service Engineer in the Semi-Conductor Industry. Part of my job was writing technical memos. Since I was well versed in writing procedural documents, I decided to become a lawyer.

I majored in Pre-law and minored in Native American Studies. During my course work, I took my first fiction and expository writing classes and discovered I enjoyed writing creatively. It wasn't until the end of my sophomore year that I registered for a poetry class and found I had an aptitude for the genre. Late in the semester, my Professor, Alan Pope, alerted me to a scholarship for Native American writers. I applied and received the award: a poetry workshop at the Taos Summer Writers Conference! In that year of 2006, Poetry with a capital P was revealed to me. I changed my major/minor to Creative Writing/Music. I started concentrating on language and music like never before. I had found the missing component in my pottery. My writing was the savvy I needed to put my poetry into my pottery. A new phrase and phase emerged which I coined *poettery*.

My initial poems pertained to the practice of Pueblo pottery. Moreover, the old fables I heard from my youth gave me strength to write in the same manner and bestow homage to the old storytellers of Laguna. For those reasons, I begin writing poems on my pots. I discovered writing inside clay bowls added that voice of longing to be heard. As a result, my pottery can resonate further, unfolding a musical dimension in the form of language. I was no longer just painting pots for hours on end but also contemplating poetry's intrigue. The skills of a potter and musician helped my perception of figurative writing. In my case, polishing pots or rehearsing musical compositions on the piano enriched my understanding of form, repetition, rhythm, meter, and tonality.

Before long, I embarked on incorporating Keresan words into my poems to heighten the vocal tonality of my poetry. Equally important, I wanted to perpetuate our endangered language among our tribe, especially for our younger generations. I view poetry as an avenue for Keres language retention. Ideally, our youth could ask their parents or grandparent about a Keres word and apply it to a Keres sentence. By learning one word or sentence a day, they could surround Keres words with poetic devices of English to write some interesting poetry. This approach would commit the Keres words to memory by action of writing and reading verse.

For our language to prosper, the younger generations will have to cherish both Keresan and English grammar. Obviously, the English writing system is the vehicle for our native vocabularies and dictionaries. I strongly believe that the only way our language can be perpetual is through implementing Keres in the local school systems from kindergarten immersion to high school language arts. My personal goal is teaching Elementary Education with this emphasis. So why is the majority of Laguna youth seldom speaking fluent Keres anymore?

The language shift from Keres to English occurred when the people stopped speaking to their children in their native tongue. The thought was that teaching their children English first would enable them to advance faster in the white man's world. Also, many families moved away for employment opportunities off the reservation and spoke only English to their children. The commerce of Interstate 40 passing through the reservation's core exposed the Laguna people to the influx of Americana. Consequently, Laguna Pueblo is a more progressive tribe than many others. The Pueblo values higher education and has fostered numerous scholars and educators. However, the challenge the tribe currently faces is reversing the language shift. This will take dedicated teachers and specialists qualified to resolve the widespread loss of Laguna Keres. There is no easy solution, but successful comparative models are available to study such as the Hawaiian Immersion Program.

What else can be done? Television, radio, smart phones, and the internet are some of the entertainment venues today's Laguna teenagers spend their idle time with. How do we infiltrate the tornado of technology and highlight Laguna language to be more interesting? Modern implements could be utilized to teach. An immense undertaking has to occur throughout the entire community so that speaking Keres becomes chic and desirable among our younger generations. The voice of our youth has to be heard to accomplish this.

My neighbor, Brandon, a Laguna teen-ager, spoke of a dream he recently had. His departed mother came to visit him. She was standing on the other side, behind a table. On the table were two feathers of eagle plumes. His mother took away one of the feathers and put

it by her side. She turned towards her son and said, "Your language is dying!" After waking, Brandon thought of ways he could learn his native speech. He wished his tribe had a Keres App or a Keresan Dictionary.com so he could look up any word and hear the voice recording. In Brandon's household, Keres isn't spoken fluently anymore. Shortly thereafter, Brandon began attending Keres language lessons once a week in his village of Paguate.

Brandon's dream reminded me of my Grandma Linda's old horse drawn wagon without any wheels. Hanging on the wall in the back of the barn, dusty wagon wheels and hoops anticipate their re-attachment once again, but the old horse-and-buggy days are gone. I perceive the wagon as our language. The wheels are part of the Laguna Tribal Government, and the hoops are part of the Laguna Language Preservation Society. These two entities have to work together with the schools and community to provide mobility and protection for our *dashiya*—language. The horse is the youth of our pueblo, pulling *dashiya* forward, down the road towards language revitalization. This ideal analogy is the hope I have for our Laguna Keresan. For that reason, I dedicate this book of poetry to the future generations of native speakers embracing the threatened languages of the world.

Ultimately, *Ears of Corn: Listen* is a poetry book of past traditions and present cultures, intertwined with celebration and ceremony of thought. Mother Wisdom-Thought Woman, bring forth your knowledge to our people. Your music through poetry plays like an earworm, continually reminding us not to forget the old tales and long ago legends of *Hamaha*. Great spirit of reason, guide us through the 21st century. May my poetry and pottery always ring true all imagery of you.

—Max Early
 February 2014

1. "Benjamin Franklin to Sarah Bache, January 26, 1784".
 Manuscript Division. Library of Congress.
 www.loc.gov/exhibits/treasures/franklin-newrepublic.html#29.

2. J. M. Gunn, "History of the Queres Pueblos of Laguna and Acoma",
 Records of the Past, October 1904, 292.

INTRODUCTION

Growing up in the Acoma and Laguna Pueblo communities in northwestern New Mexico means growing up among juniper covered mesas and sandstone canyons just walking distance from villages like Deetseyaamah, Paraje, Acomita, and Mesita. And Paguate where Max Early grew up and has lived a good deal of his life. These are villages where Pueblo people farm their lands— growing corn, beans, squash, chili, onions, and growing apple, pear, peach orchards. And, for ages, using the Rio San Jose for irrigation since who knows when, even though uranium mining-refining in the 1950's-1980's rendered the river unsafe for domestic and agricultural use. It means growing up amidst very active Indigenous cultural communities rich with traditional ways that are Laguna and Acoma in general but ways that are also distinct and unique according to their local histories and traditions of older knowledge that are very particular and special to each Pueblo tribal community.

It also means growing up within the changes caused-created by uranium mining at Anaconda's Jackpile Mine near Paguate that was part of a massive uranium mining-refining industry that extended from Laguna Pueblo to Church Rock near Gallup in the western part of the state. And also earlier changes created by the "Santa Fe railroad," as local people call it, and Route 66, electric power lines and gas and telephone lines crossing Indigenous homelands. And resultant interactions with other U.S. ethnic peoples of Hispanic and Anglo-American heritages that create or cause economic-social-cultural changes that are now a way of life along with the older on-going traditional cultural lives that Laguna and Acoma peoples have always known.

Although not always reflected nor fully visualized in terms of modern social-cultural changes common today, this is what is brought forth in the poetry of *Ears of Corn: Listen* composed by Max Early in his first major book. A distinct voice of today's social-cultural spirit is heard in the conversations, thoughts, and feelings of the poet and people he presents. Poetry is more than poetry when it is a voice of

land, culture, and community. Grandma's words are distinctly hers, as are those of other relatives, since the poet strives to give us the present moment of today. The Laguna Keres language presented as written script occasionally is represented phonetically, but it is close enough to the original since traditionally the language was oral only. As a writer from Acoma whose oeuvre is based on the Acoma social-cultural community whose language is also Keres, I've often found myself at odds with English language limitations. It's good to know a poet younger than I is dealing with the limitations prescribed by English language use. Hopefully, in the future we'll also be more inclusive of the social-cultural changes occurring today—including those which are most challenging especially in the 21st century—that must be a major focus of our Indigenous perspective when we write about and from within the voice of our Indigenous community.

—Simon J. Ortiz
 July 2013

Ty'ee-<u>tra</u>

SPRING

CONVEYING SPRING RAINS

Spring skies parched, clear and white blue,
Rainmaker smokes with mountain spirits,
Puffing cumulus clouds over *Tsee-binna*,
Deserts are rainless without a dance.

Rainmaker smoking with mountain spirits,
Thunderclouds burst over mesa tops of piñon.
Deserts are rainless without a dance,
Raindrops are always perfectly round.

Thunderclouds burst over mesa tops of cedar.
Somewhere rain is falling on Mother Earth,
So raindrops are always perfectly round,
Tapping ponds like rapid drum beat circles.

Somewhere rain is falling on Mother Earth,
To herald the *Shi-wanna* on Southwestern lands.
Tapping ponds like rapid drumbeat circles,
Frogs croak their chants and dance once more.

Herald the *Shi-wanna* on Southwestern lands,
With water designs of drizzling cloud drops.
Frogs croak their chants and dance once more—
Sunrise ends their showering leap of music.

With water designs of drizzling cloud drops,
Women draw water in painted bird *Ollas*.
Sunrise ends their showering leap of music;
Now they walk bearing jugs above their heads.

Women draw water in painted bird *Ollas*—
Red Woman and Blue Woman balance
As they walk, bearing jugs above their heads,
Home to their mother, *She-guy-ya's* house.

Red Woman and Blue Woman balance,
Dawdling along the ditch of running stream,
Home to their mother, *She-guy-ya's* house.
Red Woman's swaying pot spots sister's eye.

Dawdling along the ditch of running stream,
Corn leaves glisten bright with drops of dew.
Red Woman's swaying pot spots sister's eye,
Blue Woman reaches up, saving sliding *Olla*.

Corn leaves glisten bright with drops of dew.
In the mud, *She-guy-ya* wears no moccasins.
Blue Woman reaches up, saving sliding *Olla*,
Yet loses her poise, and her pottery falls!

In the mud, *She-guy-ya* wears no moccasins,
And she says, *peh-eh-cha*, *let it rain*.
She loses her poise and her pottery falls
Like a cloud still clinging to a rainbow.

When she says, *peh-eh-cha*, *let it rain*,
Mother Earth becomes filled once again
Like a cloud still clinging to a rainbow.
We look for arrowheads after the storm.

Mother Earth becomes filled once again,
Puffing cumulus clouds over *Tsee-binna*.
We look for arrowheads after the storm—
Spring skies parched, clear and white blue.

Tsee-binna
Mount Taylor

Shi-wanna
storm clouds

She-guy-ya
A person's name,
no meaning

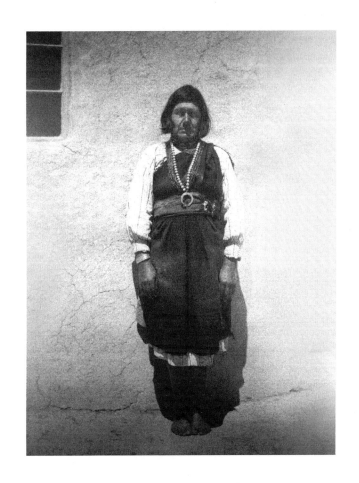

shch'isa

6

How You Got Your Name

—For Alan

One tree struck by lightning
Fashioned into a cradleboard
Protect my little one.

Three tall river willows chosen
Shaped and bent like an arch
Keep my baby safe.

Four buckskin loops on each side
Zigzag laced belt like lightning
Hold my child secure.

Six colors of the sun sought
Sewn beads around your willows
Comfort my son to sleep.

Grandfather said—

Your cradleboard was charming
So we named you *Ga-schot-tsee*
Rainbow, my Rainbow.

LITTLE FROG GIRL'S RED RUBY BEADS

The storyteller told me about Coyote's skull
As it lay there in a field of grass
Flowering sockets adorned the smile
String of red beads
Lay in his mouth
Coyote still clinging to them.

Long ago, Coyote stole those beads
From Old Frog Woman
Given by Little Frog Daughter
String of red beads
Lay in her magical pouch
Old Frog Woman kept them.

Island Queen's drops of blood
Turning to ruby tone
Before she died in Little Frog's arms
String of red beads
Lay awake through the night
Dancing beats in luminous gem.

Coyote could have brought her back to life
As he lay there in the grass field
Dreaming Coyote warned her not to adorn
String of red beads
Lay the wake 'til morrow, Island Queen's burial
A May youth touching death's hem.

Poor Coyote held on to the end
As life left his body
Flowering sockets adorned the smile
String of red beads
Lay in his mouth
Coyote still clinging to them.

Yucca You

Walking through a remnant lot of wilderness,
Dirt trail of earth guides me to school.
I seek hundreds of yuccas gracing the field
To make baskets, but I have no skill.

Oh sad banner,
"Selling 'Soft' Lofts Spring 2006",
Advertising the fateful towers.

You poor yuccas, soon bulldozed under
La Primavera Death sentence donning,
Arousing empathy, grief, and gloom:
Your plight rests in my hands.

Yucca you, born of goals and desires,
I will rescue you from the mound
With interlacing strands of delight.

Basket Maker of the North, I command:
Implant your weave techniques
Into my thought fires of compassion;
Show me which patterns to lay out.

My first yucca basket dyed red and blue
Holds fresh *ha-dranee eh scha-moo*
Gathered in spring on top of mesa above.

The rest of you yuccas now waiting for the mound,
Reach out your waxy flowers of *whoosha-gun-nee;*
Sword-shaped sails set for the land of rain showers
Before "Selling 'Soft' Lofts Spring 2006" prevails.

ha-dranee eh scha-moo
wild onions and celery

whoosha-gun-nee
yucca fruit

WARNING, MY CHILDREN

—For David

Standing on an ant hill, you were so very small,
I saved you from them, except one ant bite—
Now you are big and tall,
But you don't treat the ants right.

Ants don't bother anyone—
Why do you make them mad?
They will come back to haunt you, my son,
Listen to your Dad!

Crawling under your skin like little ghosts do,
Making you scratch and itch to the bone,
Only the medicine man can cure you—
You should have left them alone.

Instead, ask if you can borrow their rocks
To make sound in your dance rattle.
Remember this, when you put on your fox
Be kind to the ants: Don't battle!

Don't make them angry anymore,
Ants will have their way—
Feed crumbs and crackers at their door,
Try to be as they are industrious every day.

ODE TO FA-NI-THI-YA

Zim and Ger went to Thoreau
Over mesas of Red Rock
To see Fa-ni-thi-ya.

Little girl carrying green corn
O Fa-ni-thi-ya.

Lulee and Papa Max went to *Aa-da-gag*
Under suns of *Kweesh-chi*
To see Fa-ni-thi-ya.

Little girl carrying green corn
O Fa-ni-thi-ya,
Little Corn Girl, where did you go?

Zim and Ger went back to *Shi-bop pa*
Under moons of *Kweesh-chi*
Without Ceremony.

Little girl carrying green corn
O Fa-ni-thi-ya.

Lulee and Papa Max went back to *Shi-bop pa*
Over mesas of Sandstone
Without Ceremony.

Little girl carrying green corn
O Fa-ni-thi-ya,
Little Corn Girl, where did you go?

Aa-da-gag
Albuquerque

Kweesh-chi
Village of Paguate,
to pass down

Shi-bop pa
symbolic Pueblo
emergence into
this world

k'atsi chami tsiitdra

13

HENRY ACOYA

In Indian civilization I am a Baptist, because I believe in immersing the Indians in our civilization, and when we get them under holding them there until they are thoroughly soaked.

—Captain Richard H. Pratt

I. Akooya-me Yaka Hunnew

Recruited for the Indian school experiment
Earrings—*Akooya-me* was your first name
Corn Clan—*Yaka Hunnew* was your last
Taken far away from your Laguna home
Pennsylvania bound to be transformed
Kill the Indian and save the man
Carlisle Indian Industrial School can.

Stripped from traditional influences and dress
Henry is your new American first name
Acoyame will be your last
A military uniform, hair cut short
Serve time and learn the foreign tongue
Ward to the assimilation process, flung.

Photographed in Eighteen Seventy-Nine
Portrait of a Laguna Pueblo teen-ager
Henry Acoyame, you did not smile
Altered in boarding school clothes
Kill the Indian and save the man
Carlisle Indian Industrial School can.

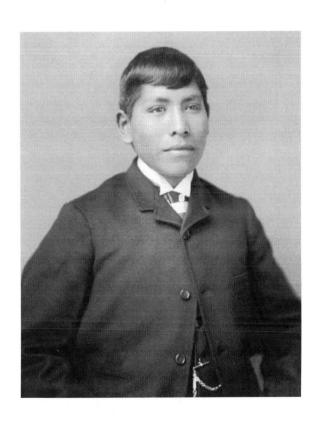

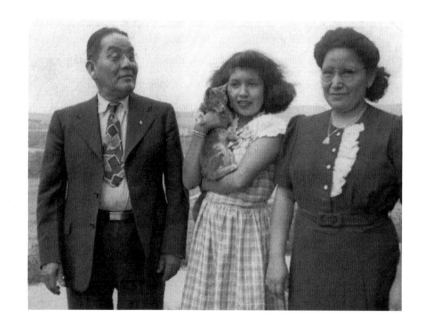

II. Hot-busha-cha

In the photo archives,
I found a black and white picture—
Great Grandfather, Henry Acoya—
At the Smithsonian's National Museum of Natural History.

I couldn't wait to tell
Grandma Linda that I found
her father's picture in Washington, D.C.,
but the excitement made me forget she was gone too.

I recall my grandmother—
She never liked it when Grandpa
and I chewed gum. She told us *A-dyeh-eh*—
It's dirty, but once in a while she would chew along with us.

I showed my mother
her grandfather's picture from 1879.
She told me he never liked it when we kids
chewed gum. He told us, *Dehmeh-shru moose-sa gu-mu-cha.*

Hot-busha-cha
chewing gum

Dehmeh-shru
It looks like

moose-sa gu-mu-cha
the cat's ass

YELLOW ROCK AND THE GINGERBREAD BOY

Whenever it rained, the grand-kids of Philadelphia, New Mexico, would look for arrowheads because wherever lightning strikes, you'll find one. We would go to Yellow Rock and scratch our names out of the yellow sandstone with flint—David, Max, Virginia, Charlene, Cheryl, and Bengie. My brother, David, traced his shoe print. On our way back to Grandma Linda's house, we would throw rocks at the pig in the pigpen and sit on top of the big boulders and rub round rocks into the giant grinding stones until we grew tired. Grandma's dog, Frisko, would show his teeth when you asked him to. "Show your teeth," and Frisco would growl up a smile. The old cottonwood tree beside Grandma's house was dead; just the trunk remained standing ten feet tall. It was struck by lightning and died before I was born, but I saw pictures of the old cotton-wood tree in black and white photographs when my grandma was younger. Grandpa would plant corn across the street at the other house. Sometimes we would have to use the outhouse over there when the water pump went out at the Seama well. It was a two-seater and had no roof. Auntie Ruthie got caught in the rain there once. She said, "It was air conditioned." The river was a football field away from the outhouse, and when the water pump would go out, I'd go down to the river to take a bath. While washing myself in the river, a water snake cruised by, so I scrubbed up in a hurry. When I got back, Grandma called me the gingerbread boy, just like Herman-nee. Grandma Linda's neighbor, Herman-nee, went crazy one day and took off all his clothes and knocked on her screen door. She said she saw the gingerbread boy.

SPRING CRAWL

Up from the ground they come,
Niya Hot-tsee—Mother Earth rouses them
with a windy-warm whisper:
Cheep-cha, Are you awake?

Tsigana, mishru du-how win-na ki-á-tra Ty'ee-tra
It's already springtime again,
arise little ones, arise.

Slow and shaky ants crawl out of bed,
rubbing winter from their eyes.
Climbing up dirt steps—
earth door above.

Dehmeh-shru da-a-weh
Like the Follow-the-Leader dance,
single file they greet Spring's arrival.

Niya Hot-tsee says,
Look there at the sky!
Huwaga moo puu-cha noya booriga
Many butterflies are here.

The awakening of the green commences,
opening cherry, apricot, and peach blossoms;
Now bees zealously zoom their zigzag dance.

White and pink petals drift,
rocking back and forth, spinning,
before they touch Mother Earth.

All the ants look up, celebrating
Spring's wondrous return.
They picnic under flowering cherry trees,
select petals as plates.

As the ants walk back home,
they spot shoots of
ha-dranee eh scha-moo
wild onions and celery sprouting.

Niya Hot-tsee sings her Spring lullaby
to the ants as Sun paints a welcome
banner of orange, red, and purple fused
across the evening sky.

Scha-moo da-wa-tra wa di-ga-a
Scha-moo da-wa-tra ba-mee doo-shra
Scha-moo da-wa-tra wa di-ga-a
Scha-moo da-wa-tra ba-mee doo-shra.

The moon of the wild celery plant is here,
so don't be lazy.
The moon of the wild celery plant is here,
so don't be lazy.

Niya Hot-tsee reminds *cee-ee eh ma-a*,
large and small ants,
to listen for the first thunder
waking snakes from sleepy slumber.

Niya Hot-tsee says,
The hummingbirds will be coming soon
along with the *Shi-wanna*, Rain gods:

Then it will be time to move
Sun to the south again.

Onyumeh wa da-a ki-á-<u>tra</u> Ty'ee-<u>tra</u>, ga-na-da Niya Hot-tsee.

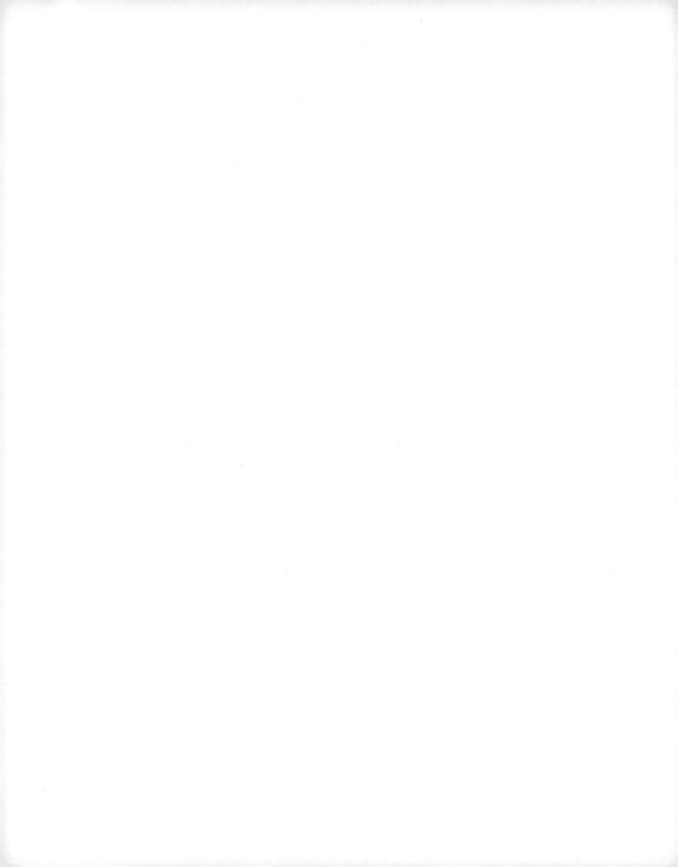

II

Kushra-_tyee_

SUMMER

SOUNDS THE EAGLES HEAR

Green corn stalks and swaying tan tassels
embrace the shrine walls

waiting for the last dance

Singers and dancers circle inside the plaza
corn stalks crack release

during the last song

Green corn ears and clenching brown hands
rhythm of bells and shells ring

time with the drum

Calling two eagles drawing rainclouds near
unison rattles shake like thunder

absorb rejoicing of dancers

Raindrops cling to fallen evergreen branches
mud oozes through slippery toes

rattles shake like thunder

Green corn ears and exchanging hands
pass the blessing door to door

enduring Corn Mother

INDIAN BETTY CROCKER

Gu-yoe
Gum-mashra<u>ka</u>,
Old Woman Spider
lives there, the Bread
House, *Baa Gaa-drew<u>tyee</u>.*
Yoe-nee, sandstone domed room
with a dirt floor, black-gray from the
charcoal ashes, *haa-gun-nee eh mi-cha.*

Gun-nee gu-tsa cedar wood split
and chopped, for the fire, piled high
Oo-biyoungnee, match ignites the wood, see

rising flames out the east door. Smoke roars up through the small opening
straight up to the sky, hu-waa-gaa. *Baa-shro gaa-cha,* Watch out, very hot
ash-white coals, ready to mop out. Test the floor with oatmeal, ask Spider
Woman to help bake the bread just right. *Dyay-nah,* it's cooked, take it out.

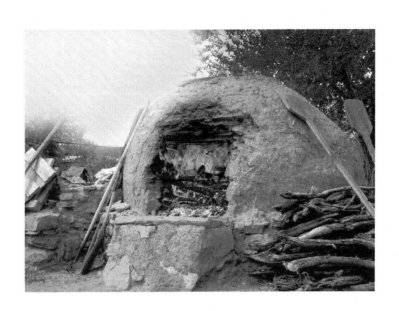

Sandstone Walls

Earth walls made of sandstone
Muddy mortar in between the cracks
Mud and straw plaster coating the sandstone surface

Sweltering summer sun shines
Glittery golden gleams of grass
Dry deductible dirt dares defy
Water working wonders well

Mud and straw plaster coating the sandstone surface
Muddy mortar in between the cracks
Earth walls made of sandstone

Weak weary walls whisper woe
Crisis chasm in chiseled chunks
Wet weathering wonder water
Time taking toll tumbling tons

Earth walls made of sandstone
Muddy mortar in between the cracks
Mud and straw plaster coating the sandstone surface

dyuuya k'atsi kuk'umish tsitdra

WEDDING VASE

Intertwining coils of clay
arch to form a rainbow,
touching fluted spouts,
painted cactus flowers.

Two lovebirds share one heart
in the belly of the pot,
Rainbow hangs over blossoms,
love in full bloom.

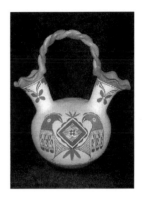

Devotion and Passion unite
like hummingbirds and nectar.
Clay transforms to stone
as strong bonds ring true.

Bride and Groom drink
from opposite fluted spouts:
Flowing water on course,
triumph's love vase.

BUFFALO THUNDER

Vast sky of rolling clouds
Herd of White Buffalo emerges
Chasing after plains of blue grass heavens

Arrow of lightning in Buffalo Man's bow
Thunder trail quivers their cue
Rain cleansing underworld

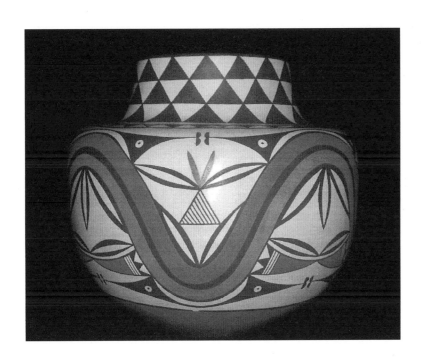

Ears Of Corn: Listen

Lazy late summer evening,
in the village of *Kweesh-chi*,
running through the cornfields,
elk descend from *Tsee-binna*.

On a lazy late summer evening, in the village of Paguate, New Mexico, on the Laguna Reservation, restless Indians cruise the cloudy, dusty dirt roads in search of elk. It was around seven in the evening when Bradley and George came over to my house to drink a few rounds and celebrate life. The discussion that particular night centered on how the elk had been coming down from Mount Taylor in the late evening hours to enjoy succulent, tender corn plants.

Rampaging corn plants down,
crisscross blades of grass,
chomping and nibbling away,
cornstalks to the ground.

In the previous growing season, the Paguate cornfields were devoured by these hungry, ravaging beasts of the field. The elk rampaged all of the corn by completely nibbling away the cornstalks to the ground and knocking the corn plants down to resemble a horizontal crisscross of oversized green blades of grass. Something had to be done to keep the balance between the continuous growth of the corn and the overgrazing of the elk. Harmony in the form of the hunt would enable the cornfields to prosper and provided game for the people.

Growth and survival of the corn,
critical to the harvest quest,
village hunters mediating nature's course,
grazing elk sacrificing life for the corn.

So we made our patrol for the renegade elk that had been devastating the cornfields at night, in the village. On our way to the cornfields, Bradley spotted his grandfather on the road, already checking the fields for elk. We stopped to talk to Bradley's

grandfather. "Seen any yet, *Nana* (grandson)," asked Bradley's gramps. "No," said Bradley, "we just got here." His grandpa replied, "There's no elk around tonight." Bradley told his grandfather that the other night, some elk had gotten into their field and smashed a gourd with their hoofs. Bradley went on to say that the crushed gourd was the same size as his grandfather's head. We all paused, then laughed at Bradley's outlandish statement, envisioning his grandpa's head lying crunched in the cornfield.

Night time devastating hunger,
jumping fences for food,
smashing gourds under hoof,
token for the village watchman.

We drove on through the cornfields in pursuit of elk—or was it more than elk we were looking for? Reflecting back on the past week of breaking up with my girlfriend had offered me severe ramifications of what and where my life was leading me to. Up ahead in the distance, going down all those winding, twisted, bumpy dirt trails, it dawned on me that I had never been down this dirt road before. I had lived all my life in this same small village, yet I never completely knew every possible turn and curve.

Down twisting, bumpy dirt paths,
pursuing and driving the game,
not knowing every turn and curve,
pondering love's lost charm.

All of a sudden, my mind wondered and pondered the reflections of life represented by these cloudy, dusty dirt pathways we chose to drive along: choosing new roads, never knowing the destinations until the smoke lifts and reveals our future as part of our past. Blinded by the light of the vehicle, those stupid elk unaware of their fate in the cornfield. Could love ever be so blind? What was I thinking, allowing myself to be scorned once again?

Deciding trails of destiny,
smoke clouds of uncertainty lift,
blind light of love's passion,
taunting fate of foolish prey.

The autumn evening air can do strange things to your senses. This is when the corn has exhausted the yield, with our love harvesting the crop. The corn plants die, but those countless days of spring and summer sunrises live on in the bounty of corn kernels. Can love live on, or does it just wither away like the corn plant? Hope is the corn seed of life planted one early spring morning as love is reborn in the same earth. Or the corn seed is taken away to different faraway lands to be planted. How beautiful a sight to behold: The re-emergence of one's love for another can never wither away but only blow into the wind, season after season.

Waving corn plants sway in the wind,
cool evening air of autumn,
carrying exhausted corn leaves upward,
away from hoof marks left in the dry mud.

Changing seasons bring on changing climates. Will the next season of my life be beautiful again? Plant the blue corn seed once more and wait and watch as suspended animation stops and the effects of a new love are born. Gather the ears of corn for the winter harvest, and remember each kernel on the cob as days spent with our loved ones. Just as corn kernels are ground into meal, then breathed upon in the right hand. I pray to the four directions—up above to the Great Spirit and down below to Mother Earth. Let the cornmeal float in the wind with my prayers uplifting to heaven on a butterfly's wings.

As the corn plant dies,
pinches of cornmeal in right hand,
offering and breathing a prayer,
blessing nature in all four directions.

During the summer, approximately ten elk were sacrificed for the sake of the cornfields. This equalization of opposing forces was necessary to control nature, with the Indian as the hunting mediator. The survival of the corn was crucial to the harvest. The threat of the elk continued throughout the growing season but dwindled with the approaching harvest. Had the elk learned their lesson not to tread in the cornfields for risk of certain death? Had they found greener pastures to partake of on the mountain? The start of the annual early fall New Mexico elk hunt created panic and spooked the creatures to run in all directions. The cornfields were left alone because the elk were now on the run by a greater presence of hunters on the mountain.

Corn gatherer grinding kernels into meal,
chewing jerky from the kill,
telling stories of elk wandering,
in the cornfields of *Kweesh-chi.*

We were hunters of the village that night, trying to chase the game to move in for the kill. By midnight, with all of the fields patrolled, we gave up our search for elk in search of other wildlife. Just three miles north off the reservation boundaries, Bradley, George, and I headed up the road to Bibo Bar to see what other kind of wildlife was corralling about. When we arrived at the parking lot of the bar, three girls were seated in their pickup, curiously looking at us. They asked, "Where's the party?" I ran inside to buy something to wet our whistles, then hastily joined my friends to see how the conversation was going. The girls had just driven off, and I asked my friends, "Just what the hell did you guys say to them?" Turned out that one of the girls knew George from a friend of a friend and didn't quite think her friends were good enough to socialize with him. Bradley yelled, "Damn, George! You spooked them." "No luck with the hunt tonight; those two-legged does don't know a prize trophy buck when they see one," George answered. Bradley and I both agreed that we should have sent George into the bar to buy the booze instead.

Chasing wildlife as mountain lion pounces,
does corral at the watering hole,
prance and glance about the night,
frightened by the venery.

The darkness continually crawled along as we rode back to Paguate through the cornfields, ready and willing to see some elk. All we encountered that night were the corn stalks, swaying in the wind. In those last easygoing days of summer when the elk gave up grazing the fields, another summer drifted by. Our drive that night transpired into good memories of getting together with friends by helping drown the sorrows and boost the spirits of a brother out of luck. "The elk are lazy tonight," I said. *"Ma-meh wa du-shra du-shra."* Everyone chuckled in response to my statement. In the Laguna language, *du-shra* is a duality word meaning both "elk" and "lazy". *Du-shra du-shra*, meaning "lazy elk". Then we abandoned the pursuit of any wildlife and headed back to my place to finish off the night. We exchanged our friendships by passing the moments of time that last summer night, playing music and singing songs. I was happy to know in my thoughts how my village confidants were there to cheer me up in time of need.

Carefree pursuit of adventure,
forgetting pain with peace of mind,
like *du-shra du-shra* lying in the sun,
summer ends too soon.

DESERT ANYTIME

Winds breeze in, greeting frequent ghosts
Blowing through empty panes
Gu-waatsee, he said, "Is anyone there?"

Whistling vibrations of howls echo about
Once solid glass now shattered reflections
Grandma and Grandpa praying to the stove.

Old Pueblo home, abandoned stone fortress
Memories of Grandma whitewashing walls
Her caress brought fresh rain scent inside.

She had a special spot by the bedroom door
Her grandchildren could not resist
We licked her walls, they tasted so good.

Gu-waatsee
Hello, how are you?

chamiya k'atsi mightdyana tsitdra

WOVEN RAINWATER

—For Randy

Rainwater *Olla*

Randy Walker Day in Santa Fe
Artist at the Southside Library
Came by to see you guys
Guess you were gone

Papa Max and Lulee
Did you answer the door?
Mayor David wants to see you

Rainwater *Olla*
Sustain Woven *Olla*
Randy Blue and Orange fibers
 Sustain cousin Jeremy Walker
 Such a talker
 A walking encyclopedia

Rainwater *Olla*

Randy Walker Day in Santa Fe
O-e-shi Tokyo Grill Sushi Bar
Came by to see you guys
Guess you were gone

Papa Max and Lulee
Went away to Santa Fe
To see Woven *Olla* strung up above

Rainwater *Olla*
Sustain Woven *Olla*
Randy Red and Yellow fibers
 Sustain cousin Walker
 Such a talker
 A walking dictionary

Rainwater *Olla*

WHY SMOKEY AND I NEVER TOOK A PIC

Smokey the Bear was there
With Clifford the Red Dog too
At the *K'awaika* Center

Fa-ni-thi-ya got free heart shoes
Tooth brush and balloons
She sank some boy in the dunk tank

Smokey ran fast as a bear could go
Across Laguna-Acoma's old football field
At the *K'awaika* Center

Jumping on a helicopter
Leaving with a shower of dust
Smokey left us in a rush

Drew-o-we-shots, he said, goodbye
To fight another forest fire
At the *K'awaika* Center

Where did Smokey go? Fa-ni-thi-ya asked
To fight the *Las Conchas* fire
Near Cochiti and Los Alamos

The Snow Cone Lady was there
And McGruff the Crime Dog too
At the *K'awaika* Center

K'awaika
Laguna Pueblo

Drew-o-we-shots
goodbye to three
or more people

chamiya k'atsi maiyuga tsitdra

CUSCO'S GARDEN

I. *Amuuka-Strammuhs*, Cusco

You greeted the cloudy blue July morning sky.
Even so, little dog clown didn't smile today—
Frisbees and tennis balls lay by your igloo,
Your perception of Armageddon lingered.
Mourning Monday, regretful Monday.

Lulee said, *Cusco just got hit by a white truck!*
Not Cusco? *Amuu'u* my Cusco, not Cusco!
Papa Max ran downhill to see his dog.

O Little Cusco, you make everybody laugh!
You've only been with us for three years—
Miniature Rottweiler, good-bye Cusco.

Why did they take Cusco away from me?
Fa-ni-thi-ya cried and cried, *Why Cusco?*
Why Cusco! You were my special dog!
When I was bored, I threw your Frisbee:
She held tight to his tennis ball.

Always protecting his family, friends, and home,
Annie said, *You were a laughing medicine dog,*
So we couldn't grind clay that sad Monday.

Tebow tied up after the ordeal;
Cusco lay still, dusty ground.
They killed our day.

They took away our happiness, like ripped off roofs,
Cyclone swift forces, throwing trailers, crashing,
A grieving moon as night hit the crystal stars.
No bark of Cusco heard on Bear Pass Road:
Why didn't they slam on the brakes?

Amuuka-Strammuhs
We all love you,
a group of three
or more that
loves you

Amuu'u
expression of
compassion or pity,
male speaker

dyanawa k'atsi

40

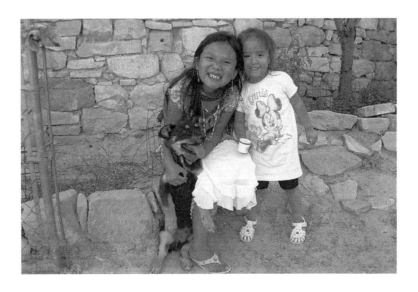

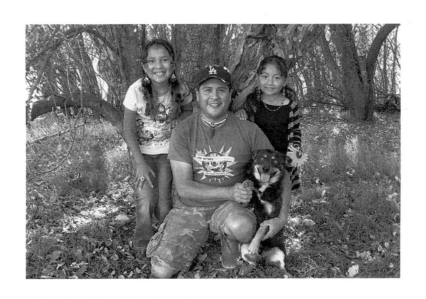

II. Morning Glories at Your Grave for Rest of Summer

While in Albuquerque, my neighbors, Arnold, Brandon, Charlene,
and Vania, recalled how you were drifting high above them. Lulee,
Fa-ni-thi-ya, and Papa Max also caught a glimpse of you, small fluffy pup.
That Monday afternoon, we could see Cusco in the clouds.

In the hot July sun, we buried you in the garden.
Fa-ni-thi-ya wept as she picked your flowers—
Addressed To Cusco: Her silver glitter
Paper hearts, Hello Kitty keychain,
A small stuffed animal frog.

Holding your chewed open tennis ball all afternoon,
She placed some of your black hair inside it.
Fa-ni-thi-ya sneezed, Cusco's thinking of you.

Like a child, we lost our beloved three-year-old.
Crying in the rain, we remembered how
You always washed your toys in the water trough;
You'd bring your Frisbee back to us
All muddy and ready to play.

III. I Saw Cusco! Sitting on the Bench!

Constantly washing your t-balls and Frisbees,
You never got tired of making us laugh and smile.
Fa-ni-thi-ya, don't feel so cloudy blue;
Cusco wants you to be happy.
Sa-dyeeya Cusco, *Guymeh-eh* Cusco, visit Fa-ni-thi-ya
In her dreams; take this ache away from her.

Drones of thunder
Cusco! Tebow!
Then I heard, *Hello neighbor*
How are you?

Cusco spoke through thunder
And when you spoke
The wind blew
With the drumbeat
Tebow, Tebow
Tebow
Tebow

Cusco said, *Hello.*
Silent thunder.
Then the wind blew
With the sound of a dog's bark.

Are you cold? Cusco asked.
I came back over.
And the wind blew
With laughter of children.

Tebow lay down by Cusco's grave:
The rain blew
With the drumbeat thunder—
Inside the house, a cricket chirped with our baby goose.

Sa-dyeeya
my dog

Guymeh-eh
please

dyanawa k'atsi chami tsitdra

43

III

Heyya-t'see

FALL

SIGNS OF FALL

Shivering oak drops a leaf
Banquet of season journeys
South with the hummingbird

Sweet nectar, sweet nectar
Dries on mouths left behind
Wipe off your sticky sadness

Cool autumn evening chills
Grasshopper wishes to fly afar
Sitting on the window pane

Climatic order rushes in
Touching down as signal
Will I see another summer

Smart ants eat in their retreat
You don't want to catch cold
Honey, close the door now

Chopped scent of cedar wood
In my arms falls to the bin
More ash for the winter winds

dyanawa k'atsi mightdyana tsitdra

PICKING PIÑONS IN SKINWALKER COUNTRY

Midmorning light soaks through the pines
As gray wolf pup runs by in a rush—
Little skinwalker oblivious to your cloak
Back in the hoop to earthborn form.

Piñon picking in skinwalker country
Gray wolf pup follows you 'round—
Piñon shell smile reflects your shades
While a crow feather floats, whirling down.

Grandmother says—

Don't eat the piñons raw or you'll get sick
And leave that crow feather alone
Or I'll burn it when we get home—
Little skinwalker wants your stash
Shoo little wolf, shoo
Back in the hoop to earthborn form.

Little skinwalker oblivious to your cloak
Roasting piñon cones in the coals—
Little wolf sprinkles salt water
Sizzle and steam to make it snow.

Little wolf says—

So you can't pick and I can dig
More for me to sniff in white cover—
Savory tidbit while telling winter stories
So what if the snakes can't hear.

dyanawa k'atsi kuk'umish tsitdra

In The Black Blue Hue Of Sunrise Dawn

In the black blue hue of sunrise dawn,
Mother fire keeps me warm.
I pray and breathe on the dry flowers,
an offering to the Deer Spirit.
Consumed by a flame,
my prayer goes up in smoke—
Rainbow full of colors
for the deer to see.

They say: *Moo puu-cha ga-schot-tsee,*
Guy on-yeh, shro egu sheh:
Look at the beautiful rainbow,
let's go over there.

Climbing the hill in pursuit,
fresh deer tracks everywhere.

Directly in front of me, *Guysh-beeshru*
The rays of sunrise
glisten on the antlers.

We have found the rainbow,
now it's time to go home.

Home to the mountain lion,
singing hunting songs of praise.
Tribute and honor to the deer,
corn pollen prayers scatter in the wind,
bless us again, Deer Spirit.

dyanawa k'atsi maiyuka tsitdra

49

A Brief History Of The American Buffalo

It would be a great step forward in the civilization of the Indians and the preservation of peace on the border if there was not a buffalo in existence.

—Congressman James Throckmorton

A dance for the esteemed
Boundless brother of the Great Plains
Roaming in the millions long before 1800

Buffalo Nation's demise
Brought down by greed
Trappers, settlers, and traders

Never heard again
Thunder in the distance
Without a cloud in the sky

Tattered remnant
Sheltered in the park
A reservation called Yellowstone

STRUCK GATHERING PIÑONS

Wanting to yell—my breath, powerless, defies me

Smell of burning hair and taste of blood
Throat dry and parched
 I cannot speak

A crooked pine tree near
 I lie on a bed of dirt and needles

Rain on my face
 like
 drops
 of
 consciousness

Staring at thin white clouds
 dissipating
 into light blue sky

Watching drops of rain water
 run
 down
 green
 silvery
 points

I am floating

 dead or alive
 with the clouds

 on their journey

 Going home with the *Shi-wanna*

STONE-BURNISHED BOWL

Polishing stone waits for her return,
To finish burnishing the clay bowl.
Steady slow, they work together
Under a cottonwood tree's shade.

She falls asleep on riverbank sand.
Polishing stone sits inside the bowl.
She dreams of a design for her pot,
As waters and shadows journey on.

She leaves without saying good-bye,
Through rain and sunlight shadows.
In between endless rows of corn,
She dances towards lightning way.

She signals rainfall on her vessel
Until water covers stone and bowl.
Clay cracks and soaks and melts.
Water hands stone back to river.

ODE TO RADIO ROSE

On Sunday afternoon, I sat down and listened to 89.9 FM's Singing Wire Program. The dedication that day was in honor of Rose Ebaugh. She was a DJ on their show for over ten years. Rose was my longtime friend since the fall of 1984. I first met Rose in class at Albuquerque TVI, when she was my lab partner in Digital Applications. We both ran in TVI's runners club. Our friendship flourished over the years. We always bumped into one other at malls, feasts, fairs, art shows, bike rallies, and pow-wows. I could always count on Rose to make it to some reception dinner I was having like Paguate Feast, my wedding, my sons' birthdays, or most recently, my mom's birthday banquet. I always gave her some outside oven bread before she left. Even at the 2008 Santa Fe Indian Market, Rose stopped by my booth, and we planned where to go for dinner. We ended up at Red Lobster with Dawn, Debbie, and Norvin. She knew how to make you laugh, but best of all, Rose knew how to be a dear friend.

Hearing the sad news, Norvin said
We lost our Rose, Radio Rose
Now I long for your reception

Dear friend, no more on the station

Rose on the air
Radio Rose
Rose of my reception

Encouraging Rose
We ran together for our causes
Your stride always kept us going

We danced and laughed at Yo's wedding

Rose on the air
Radio Rose
Rose of my reception

Reassuring Rose
You brought us new friends
Bring us together now

Broadcast your love to our people

Rose on the air
Radio Rose
Rose of my reception

Leaving when roses first bloomed
Traveling transmission lines
Hear me Rose, a shout out to you

Tuning in your voice

Rose on the air
Radio Rose
Rose of my infinite reception

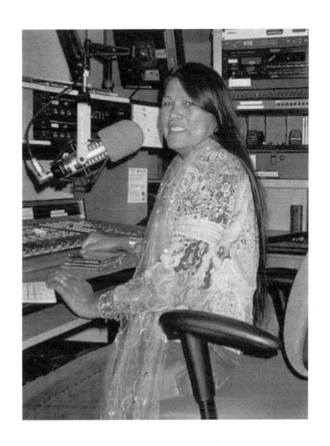

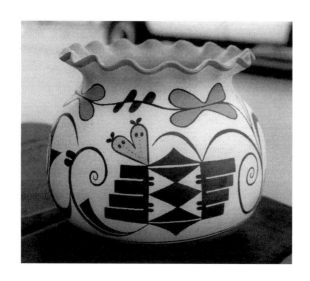

PRICKLY PEAR AND YUCCA FRUIT

Cochineal juice
Drips from Coyote's mouth

Scat of brown crunchy seeds
Runner treads

This will help you run faster

Whoosha-gun-nee
Crumbs from Fox's mouth

Scat of brown crunchy seeds
Runner treads

This will help you run faster

Whoosha-gun-nee
Yucca fruit

tamawa k'atsi mightdyana tsitdra

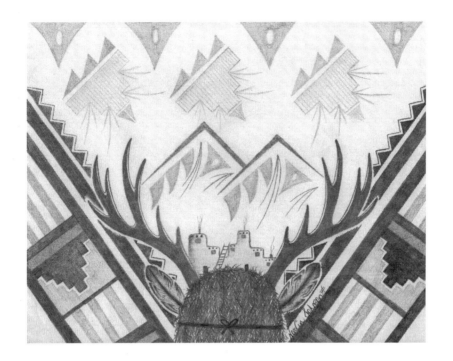

IV

Kook<u>ka</u>

WINTER

NIGHT WITH THE WOODSTOVE

On the north wall, blue balcony of Grandma's kachina dolls dance to orange and yellow flames of the woodstove.

feather shadow tall
flickering of the coals
dreamy winter's night

On the east wall, Chinese rainbow silk birds cling to evergreen vines, their vernix wings shimmering with rhythmic fire.

one hundred birds
on white silk canvas
bring family closer

On the south wall, brushed clay vessels glow with the dying embers, placed high on headboard sill, nearly touching the ceiling.

above my bed
weathered *Ollas* recall
holding cool water

On the west wall, antlers rest, staying warm with the fire, mountains return in their sleep until the drumbeat starts again.

christmas deer dance
signaling in the season
early winter morn

shch'isa wa k'atsi eeshka tsitdra

61

AMERICAN HOLIDAYS

Pueblo Mother, Mary America,
Liberty is my middle name.

Baby Jesus, my New Year's Baby,
Play with your Ground Hog
Chasing shadows.

Joseph, you are my Valentine,
My heart pierced by your bow and arrow.

Wise Man, Saint Patrick,
Chase the snakes away from my child,
Give him clover dreams of Trinity.

Easter Bunny, comfort my boy to sleep,
My tears fall on your Easter egg.

Jesus, is it Mother's Day yet?
Father's Day is next;
Remember your Daddy, In God We Trust.

On Fourth of July, the eagle flies,
See the fireworks, my son.

Labor Day, Jesus, time to rest,
End of summer and back to school,
A three-day weekend you'll cherish soon.

Happy Halloween, Son,
Wise Man, Grim Reaper,
Brought you a kitty and a pumpkin.

Turkey Day is here,
Let's feast with the Native Americans.

Happy Birthday, Jesus,
Wise Man, Santa Claus,
Has a present for you.

Merry Christmas, my dear son,
May the little penguin and Rudolph
Make you laugh.

RELATIVE PASSING

Smoke cloud in the looking glass,
Past of black and white ghosts;
Empty smoke-colored gulps,
Fusion of parched and starving growls.

Shuumu Tsibewidrani

Steaming savor of stew mingles
With blowing breath on meal;
Cool down your thoughts of me,
Little dish filled with morsels.

Gun-ni-shi-ya

Shuumu Tsibewidrani
He/she is preparing
food for the dead

Gun-ni-shi-ya
food left
for the spirits

Orange coals and white ash yawns,
Smoking morsels for yesterdays.
Cool down my thoughts of you,
Come eat and feel our yearnings.

Shuumu Tsibewidrani

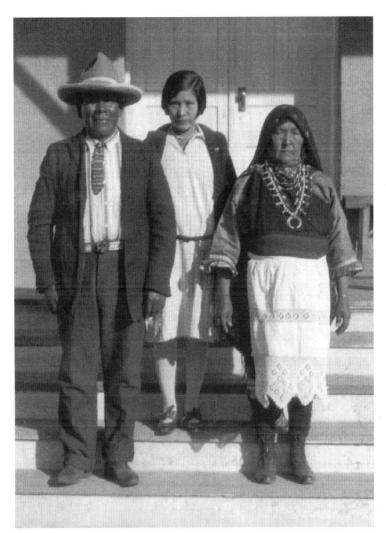

WANDERING FOX

He was like a fox
In the light of the dark lake
Near the shores of Blue Water
Bridging over the purple hue of dusk
Setting forth destruction
As sands melt into molten glass rivers.

He wasn't like a fox
Coming out of his *gana-dyaya* skin
Bridging over the blue hue of dawn
He was never born human
Until Spider Woman spoke of evil ways
Weaving time into countless blankets.

gana-dyaya
witch

Sa-meata

My dreams lingering,
morning winter awakening,
my dough rises.

My dough swirling,
kneading out trapped bubbles,
rise once again.

Fifty loaves inflating,
sitting on seven bread boards,
over kitchen table.

The *baa gaa-drewtyee* rousing,
setting bonfire branches ablaze,
feed the oven.

Adobe floor mopping,
steaming aroma of wet earth,
clear the coals.

Wooden shovel guiding,
sliding fifty tin pans in place,
watch bread brown.

Round loaves now cooling,
Cutting up breads for banquets,
sa-meata on my lips.

baa gaa-drewtyee
bread house

sa-meata
sliced bread

shch'isa wa k'atsi mightdyana tsiidra

SNOWFALL SIGHS

January snow falls on flat rooftop

Desert white and skies gray

Puddle of slush

Drip by drip

In pots and pans

Splashing water on credenza

January snow falls on flat rooftop

Painted clay *spuna* on table sleeps

Slipped *ep-cha* and red ocher

Ready for firing

But droplets

Gradually submit

Soaking shape to wet

Painted clay *spuna* on table sleeps

spuna
canteen

ep-cha
white clay slip

shch'isa wa k'atsi kuk'umish tsitdra

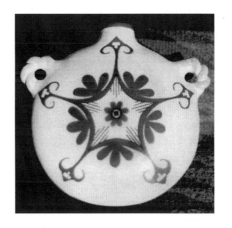

MATRILINEAL WINTER

Traditionally, at Laguna, the house is given to the oldest daughter
At Acoma, the house is given to the youngest daughter
The house belonged to Grandma Marie
Given to her oldest daughter, Jane
Soon, Jane gave Sister Clara
The family home

Three sisters in their winter
Share their mother's house
They are Orion's belt
Wintry sister stars

Three stars softly fading
Reminisce festal shadows
Mom's chili stew cooking
7-UP in the Frigidaire

Three sisters embrace home
But not like they used to
Keep moving around
More aches flare

What do we do with your house, Mom?
We feel bad that you're getting old
We'll help you when we can
We miss the old you

Serious oldest daughter
Humorous middle girl
Cheerful youngest baby
Wintry sister stars

mightdyanawa k'atsi eeshka tsitdra

DEFENSELESS TO WINTERTIME DARKNESS

—For Andrea

Down snowdrift icy road, she knocked on faded turquoise door.
You need to repaint your door and windows bright blue, Grandson:
It wards off evil, brings you good luck, a color witches tend to shun.
Grandma Mary, nobody believes that anymore, way too old school.
Oh, Manual, please draw your curtains at night, so witches peeking
Can't harm you. Guard against the evil eye, hang *ojos* on your wall.

Freezing chill of winter night, when insidious witches masquerade.
Traveling as luminous spheres, they move erratic on gleaming snow.
Some ride tides of blizzards in dark solitudes of haunted whirlwinds.
Midnight meeting of village witches, set to magnetize a black stone,
Summoning surrounding lightning bolts and strong magnetic fields:
Polarize the lodestone, polarize the lodestone, polarize the lodestone.

Lodestone knew two hearts of a witch could be controlled by greed.
Enhancing her strength, enriching her knowledge, easing her switch
Into any enchanted shape she desired, invincible, he would draw her—
Witch, never neglect nor misplace me or you will pine away and die.
In clay bowl of water, feed me needles and steel specks, my potency.
Should someone steal me, menace with madness and wither to bone.

Youngest witch was given black stone magnet to aid her debauchery.
She lurked in shadows, unbeknownst at dawn, back to her adobe home.
On kitchen table she sat the stone in water, feeding it iron fragments.
Nibble while I rest, 'til icicles harden, rouse my nocturnal mayhem.
Slush melting, she slept and didn't hear Manual's knock on the door.
He stepped into her abode, saw the clay bowl, then snatched the stone.

In winter's obsidian blue dusk, she woke up wailing like the winds.
Ominous doom ran down her spine, deranging her mind with venom.
She surveyed who'd stolen her talisman, gazed into water of clay bowl.
I'll steal your heart, Manual, as my sanity drifts and my skin shrivels.
You have no safeguards against us, so easy your dwelling is to enter.
Peering through your window, I'll shoot cactus needles into your body.

As wintry darkness closed in, he could care less to draw his curtains.
Soon, he heard fast footsteps on the roof, hard scratching at the door:
Prowling witch fogged the windows, slipped her silhouette inside.
Manual saw a shadow beside him move and disappear as he turned.
Just as the lights flickered out, masked breathing filled his bedroom.
Suffocating with senseless malice, savage sounds mirrored his fear.

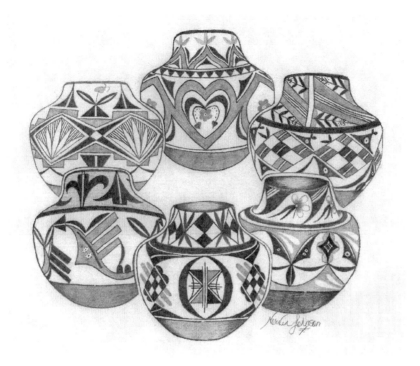

V

Kweesh-cheh
shrama
CLAY
VARIATIONS

CLAY VARIATIONS

Rings of clay coils unite smooth with a gourd
Vessel without fire will liquefy to soft earth
Intense constant heat transforms need
Serving purpose
Clay bowl

Yearning to master techniques of his ancestors
His clay *Olla* useless wanting fire process
Intent with desire, he seeks Flame Girl
Acquiring her
Know how

Covering the entire pot with large pottery shards
She stacks dry buffalo dung up and around
Fire sparks fuel bringing forth change
Clay to stone
Pot cools

SHE SAID

Essentially you came from gray black clay and white sand
Niya Hot-tsee—Mother Earth
brought you here before me
She said
Ask
Creation
to come to those who seek
Tsizenneenagoo—Thought Woman
Convey your thoughts through me like trickling raindrops
Shower me with inspiration
Precipitation of notions
She said
Grind
the clay
down to a powder
Niya Meat-zee—Mother Clay
Maneuver my hands to mold you into a vaporous cloud
River sleek stone smoothing
white clay on your body
She said
Paint
rain designs
yucca brush strokes
Shi-wanna—Rain Gods
Dancing footsteps of lightning and melodies of thunder
Wild spinach, sticky syrup
Clay red and yellow
She said
Fire
clay *Olla*
shifting to stone
Dyu-nee Moo-dyeh-tra—Pottery Boy

THE WILL OF THE CLAY

Black and white clay
Makes you a clown
And you were gray.

Did I know your way?
Not until I ground
Black and white clay.

I studied your play
Styling you into a hound
And you were gray.

But who is to say
You won't run to town
Black and white clay.

You could be a stingray
That has a frown
And you were gray.

I made you a blue jay
That was quite round
Black and white clay
And you were gray.

ANOTHER CLAY STORY GONE

The clay cries out in my sleep:
Bored from lingering,
When will you mold me?

Exigently holding you
In the arms of awakened obligation,
I strike accordance.

As time winks away,
I cherish our spring fate
Building your intended shape.

Evanescent clay heart,
Too early you vary
Into stone permanence.

Caressed for a final moment,
Another intrigue of contemplation,
Let go to galleries of grandeur.

THE CLAY LIZARD

—For Florence

Before Lawrence went, he told me
He was from the Laguna Lizard Clan.
He gets into the house sometimes;
I find clay and mold him down,
Taking him outside to dry.

He's crawling on my screen door,
Looking in at me with his beady eyes.
He gets into the house sometimes,
Crawling back to my damp clay.
He licks up fruit flies under camouflage.

Fast runner to corner as he detaches his tail,
He assumes I'm a predatory potter.
I find clay and roll him a new tailpiece;
This time I attach him to my pot,
Taking him outside to dry.

Before he set himself free,
He said, "Look where you're stepping.
I'm out here, watching over you.
Don't ever hurt me, please,
And feed us lizards, something sweet."

kuk'umishwa k'atsi eeshka tsitdra

KEEPER OF THE LIGHTNING BOLTS

Plain clay bottle hand-formed by man
Traditionally fired spirit from within
Potterylike cloud with an open lid
Selected for your symmetry

Keeper of the Lightning Bolts
Manifest your universal mystery
Electrify your Thundercloud vessel
Through winding path like river branches

Crowning top of silvery copper charges
Positivity flows through your veins

Storm attracts forces within the pottery cloud

Negativity flows through your veins
Solid bottle base of purple black charges

Plain bisque bottle cast from potter's hands
Lightning passes through you instantly
Heating the air swell of giant wave
Roar of rumbling deep thunder

Keeper of the Lightning Bolts
Manifest your echo among the stars
As flash of light overcomes resistant air
Bring forth currents of electric blue clouds

Shimmering watercraft illuminates summer night's sky.

I Love You To My Decay

How you became my thrill,
I said to the clay,
Then later, my skill.

Is this your will,
Or was it my way
How you became my thrill?

I'll grind you through the mill.
Is that the price to pay,
Then later, my skill?

I saw you waiting on that hill.
You made me feel so gay.
How you became my thrill.

So I knead you still,
And watch you lay,
Then later, my skill.

Do not think this ill:
What do you want me to say?
How you became my thrill
Then later, my skill.

STAIRS OF REVIVING POTTERY

—please climb up the stairs of this poem—

Shroat-wehmeh masterpiece of endeavor

Go face the fire, ringing the pitch desired

Burnished body of brush-stroked clouds

Now dry and cure, sanding you smooth

Revived passion, slicking walls together

Rolling hand-coils of clay in four circles

Or form, *Straniyasheh Mitsi*, will decide

I'll start over again, same coveted shape

Knead and pound all pockets of air away

Hands sticky, goo slides between fingers

Leaving the gelatinous clay ready to mix

Of preceding notions as water vaporizes

By releasing old thoughts, I stir the bowl

Pool of muddy forgiveness urges me on

Slowly dissolving away, my flaw melting

My last creation nestles in the clay water

Shroat-wehmeh
Never mind, let it go

Straniyasheh Mitsi
Our Mother Clay

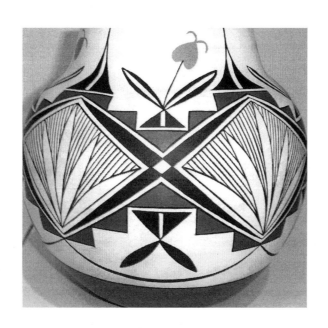

kuk'umishwa k'atsi tama tsitdra

kuk'umishwa k'atsi shch'isa tsitdra

GRANDMA LINDA'S POLISHING STONE

Before I began to work with Laguna clay,
I was told only women could make pottery.
Traditional ways heeded by my grandmother,
Yet she gave me one of her polishing stones
She'd sought from a bed of cool *chin-na* water.
This entrusted gift soon sparked my fire.

A dying tradition urges intent and artistic fire.
Curiosity in me revealed the charisma of clay.
Determined and self-taught, I built a large water
Olla to honor the matriarchs of Pueblo pottery.
Breaking gender taboos didn't turn me to stone.
I had an approving smile from my grandmother.

Mameh on-u-meh gusa-sue, said grandmother.
Now find someone to teach you how to fire.
You also can use any one of my grinding stones
To crush and crumble *taash-gunna* and clay.
Remember, your spirit is part of the pottery
Just as clouds cradle life through rainwater.

She said, When it rains, let's collect fresh water.
(I watched wrinkled hands of my grandmother
Gather rain from barrels with bowls of pottery.)
Bring them inside while I warm up by the fire;
Now pour some rain in the powdery gray clay.
Treasure this mud dough like a precious stone.

Not long ago, we used corncobs and sandstone
To smooth wares later wiped down with water.
We burnished only at daytime, slip of white clay.
Many customs grow old, like your grandmother:
When I'm gone—feed me when you build a fire,
Stay diligent and attain patience with pottery.

chin-na
river

Mameh on-u-meh gusa-sue
It's really nice, you
sure know how

taash-gunna
old pottery shards

maka
gourd dipper

kuk'umishwa k'atsi mightdyana tsitdra

When she departed, I gave her my first pottery,
Lustered white with my heirloom river stone.
We collected and burned her clothes in the fire,
Her *maka* still hanging, where she ladled water.
Musing continuum with my dear grandmother,
Displaying her ways of working with our clay.

My grandmother knew I would fall in love with clay:
Holding reddish-brown stone—I buff my initial fire.
Ritually smashing pottery, she sends us wondrous water.

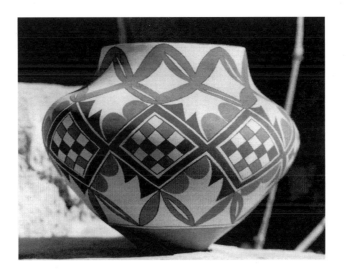

About The Author

Max Early was born into a tradition of potters and clay. He creates traditional pottery in order to help save the art of pottery making in Laguna Pueblo. When he began to focus on writing, he continued his passion for celebrating his family, culture, language, and the enchanting New Mexico landscape.

Honors and awards for Early in pottery include a Fellowship and a Lifetime Achievement Allan Houser Legacy Award from the Southwestern Association for Indian Arts; a Native American Community Scholar Appointment: Office of Fellowships and Grants, Smithsonian Institution, Washington, D.C.; the Heard Museum Guild Indian Fair & Market Judge's Award in Sculpture; the Gallup Inter-Tribal Indian Ceremonial–First in Effigies/Special Elkus Memorial Award; and the Santa Fe Indian Market-First in Traditional Pottery/Wedding Vases.

Early's work appears in the permanent collections of the Dr. J. W. Wiggins Collection of Native American Art, University of Arkansas, Little Rock, AR; the Eiteljorg Museum of American Indians and Western Art, Indianapolis, IN; the Maxwell Museum of Anthropology, University of New Mexico, Albuquerque, NM; the Denver Art Museum, Denver, CO; the Cincinnati Art Museum, Cincinnati, OH; the Indian Pueblo Cultural Center, Albuquerque, NM; the Museum of Indian Arts and Culture, Museum of New Mexico, Santa Fe, NM; and the San Diego Museum of Man, San Diego, CA.

Early's work also is shown at the Case Trading Post, the Wheelwright Museum of the American Indian; Andrea Fisher Fine Pottery; and the Adobe Gallery, all in Santa Fe, NM; at Bryan's Gallery, Taos, NM; and the King Galleries, Scottsdale, AZ.

maiyukawa k'atsi eeshka tsitdra

About The Artist

Born and currently a residing member of Laguna Pueblo, Marla Allison utilizes challenging techniques, mediums, and persistent evolvement of history, contemporary art, and the study of Hopi and Laguna Pueblo pottery designs in her work. These designs are of great inspiration to her and have been interwoven into many paintings throughout her career.

In 2010, Allison was awarded the Eric and Barbara Dobkin Fellowship from the School for Advanced Research and the Inaugural Innovation Award at the Santa Fe Indian Market. Recent book covers and publications include *Ditch Water Poems*, by Joseph Delgado; *The Denver Quarterly* (Fall 2013); and Michael Abatemarco's "Second Skin", *Pasatiempo* (August 2013).

Allison's work can be viewed at the Berlin Gallery at the Heard Museum, Phoenix, AZ and the Lovetts Gallery, Tulsa, OK.

Allison explains, "My art is what lets me connect the past to my future. My paintings are based on the contemporary, which borrows from the past. I paint so I remember where I came from. I paint so others can remember where I come from. I paint to be remembered."

Acknowledgments

A big *Dawa-eh Sai-hoba* to all family, friends, and clan relations for your guidance, camaraderie, and encouragement. I cherish your untold stories.

Sincerest appreciation to my editor, Andrea Watson, for suggesting the traditional forms of poetry which greatly enhanced my range as a poet. Thank you to my book designer, Lesley Cox, for her talent and fine eye for both poetry and pottery.

Grateful acknowledgment to the University of New Mexico's Creative Writing Department for developing my poetic endeavors, especially to my professors and instructors: Lisa D. Chavez, Amy Beeder, Valerie Martínez, Marisa Clark, Kareva M. Allain, and Levi Romero.

With gratitude to Sharon Oard Warner, founder of the Taos Summer Writers Conference, for providing New Mexico's writing community the greatest possible gift. This was where I met my brilliant editor, Andrea Watson, while attending the conference in July 2006.

Noteworthy thanks to Professor Alan Pope for discovering my potential and directing my attention towards writing scholarships available through the English Department at UNM.

I am forever grateful to Eileen Lente Kasero for sharing her knowledge of our native Keresan language. *Dawa-eh Sagooya, Skunama.*

Sweet thanks and kudos to Marla Allison for the front cover art, *Summer Ends Too Soon.*

Endearing gratitude to Norvin Johnson for providing the drawings placed before each section.

maiyukawa k'atsi tama tsitdra

Special thanks to the following publications and blogs in which these poems first appeared:

Conceptions Southwest: "Ode to Fa-ni-thi-ya" and "Piñon Picking in Skinwalker Country".

Contemporary Native Art Magazine: "Defenseless to Wintertime Darkness", Issue 0, March 2013; "Conveying Spring Rains", Issue 1, August 2013; and "Night with the Woodstove", Issue 2, January 2014.

Uncle Paulie Blog (Road to Indian Market): "She said".

maiyukawa k'atsi shch'isa tsitdra

Notes On The Photographs